D1418404

the dog album

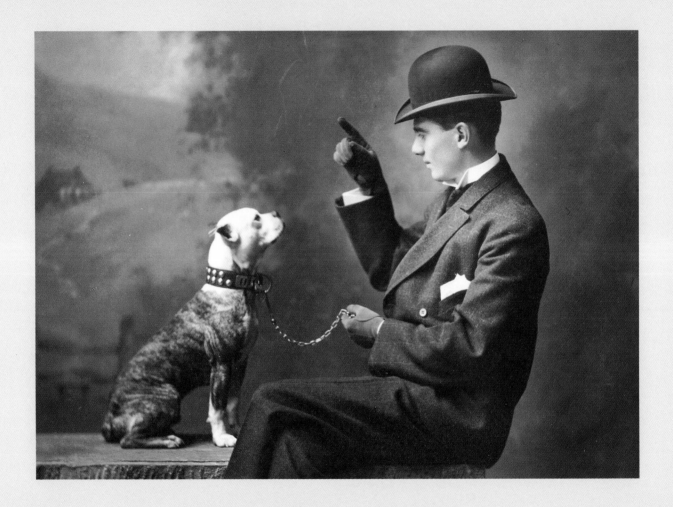

the dog *album*

Studio Portraits of Dogs and Their People

Gary E. Eichhorn and Scott B. Jones

Stewart, Tabori & Chang
New York

Published in 2000 by
Stewart, Tabori & Chang
A division of U.S. Media Holdings, Inc.
115 West 18th Street
New York, NY 10011

Distributed in Canada by
General Publishing Company Ltd.
30 Lesmill Road
Don Mills, Ontario, Canada M3B 2T6

A CIP catalog record for this book
is available from the Library of Congress

ISBN 1-58479-000-8

Printed in Singapore
10 9 8 7 6 5 4 3 2 1
First Printing

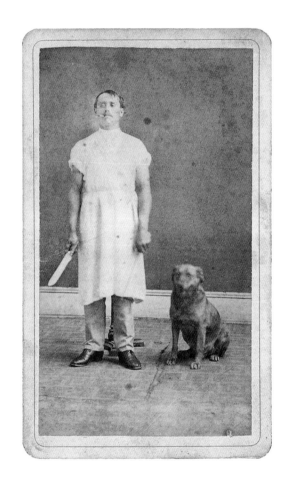

acknowledgments

This work stands as a tribute to my co-author and friend Gary Eichhorn, who shared with me a love for "antique" dog photography. Gary passed away before this work could be completed, but it was his last wish that this book be published for the enjoyment of others. He is greatly missed.

Many friends and acquaintances contributed to our dream of publishing this collection, but a few deserve special mention. Gary Ewer has provided generous support, both general and technical, and has been especially helpful working with daguerreotypes. Ted Clark has donated many hours assisting with layout, graphics, and manuscript preparation. Susie Osborn's feedback on dog breeding and identification was invaluable; Lorraine Jones's proofreading of the manuscript at every stage was equally helpful.

—Scott Jones

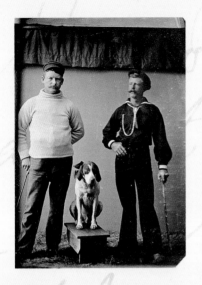

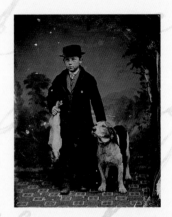

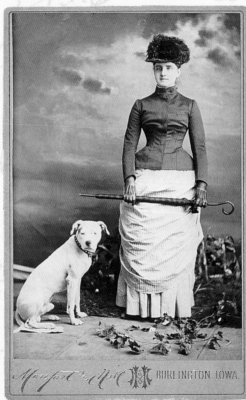

Manfort & Neill BURLINGTON, IOWA.

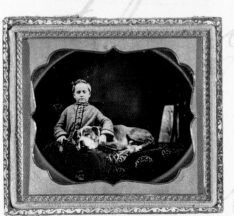

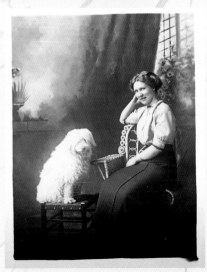

contents

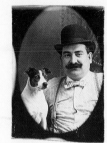

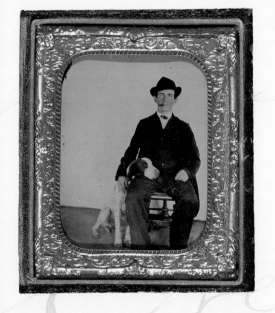

foreword

When our chief—I might say only—ambition was to get a picture without those dull, black shadows that, like some genius of a Rembrandt, ever haunted our first dark dawnings in the art, when artistical and picturesque effects gave us but little, if any, concern. I had the pleasure of daguerreotyping one of the most charming pictures of an infant I have ever seen. The mother of my wee subject, like most mothers, wanted her darling taken alone and full-length—always, as is well known, a most trying task, and this time particularly so; for, at every effort I made to perform it, I was opposed by my little sitter to the full extent of his tiny lungs; and, although tiny, to such an extent that I was about to give it up as a thing impossible to accomplish, when a large Newfoundland dog belonging to the family, who had been all this time anxiously watching the mysterious operation, now thinking that his young master was being rather roughly dealt with, stepped proudly up to his side, and with an air of defiance, stood for a moment looking me full in the face, and then gently nestled his head in the child's lap. This acted like magic upon his fair companion, who instantly changed his countenance from fear and distress to that of conscious security; and, throwing his fat, dimpled arm around his noble protector's neck, remained perfectly quiet and composed, seeming to say—if smiles say any-

thing—"Touch me now, if you dare!" What a picture was this, so natural and so perfectly beautiful! I could not think of letting it pass away like a morning's dream, without trying to catch its shadow. Everything now was favorable: the room was still—all, indeed, seemed spell-bound. I was afraid to stir, lest I might break the charm and spoil this beautiful picture. My plate had grown sensitive by standing. With breathless silence I drew the shield, and in an instant was fixed upon silver a picture worthy of being wrought in gold.

<div align="right">

—M. P. Simons
Anthony's Photographic Bulletin,
Philadelphia, Pennsylvania, 1871

</div>

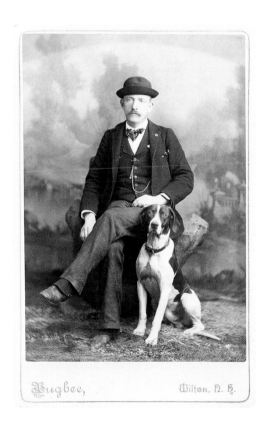

introduction

The domestication of dog by man has been documented from the Stone Age forward. Many animals were domesticated by early man but dogs were certainly the first. It is the only animal willing to include man as part of the pack and even follow him. Dogs have always been, and will remain, man's best friend.

The original canine slowly evolved through natural and selective breeding into distinct breeds. Throughout most of the dog's history, the force propelling this division into breeds was human need. Breeders selected their stock for functional purposes like herding and hunting. Cosmetic appearance, unless integral to function, was secondary. Because such breeding was performed by uncoordinated efforts, the appearance of dogs varied significantly from today's recognizable breeds. It was only during the late nineteenth century that the idea of canine breeding developed as a hobby and sport and standards of conformed appearance were established.

The American Kennel Club was founded in 1884 as a coordinating body for different "breed clubs." Its main purpose was to establish uniform rules, setting standards of appearance for the various recognized dog breeds. Individual societies created the definitions of ideal appearance and then bred selectively to attain those goals. These ideals have changed with fashion over the last century, and what was the standard for certain breeds in the nineteenth century might not be recognizable as such today.

Photography, for all practical purposes invented in 1839, provided a vehicle for documenting these developing dog breeds. Although the majority of nineteenth-century dog photographs reflect general categories rather than the highly specialized breeds we see today, as time progresses the dogs begin to be more identifiable, and the occasional early purebred can be recognized.

Taken as a whole, these images reveal an even more compelling aspect of dog life: their relationships

to their owners. That dog owners have always considered their pets members of the family is evident from even casual viewing of antique photographs. In fact, some of the first photographic images taken during the nineteenth century include the dog.

The purpose of *The Dog Album* is to share a nineteenth- and early twentieth-century photographic collection showing images of dogs with people taken in a studio setting. There were a number of major photographic formats developed between 1840 and 1900 that were popular with the general public: this book is organized according to these types.

Inherent in this presentation is the recognition of the art of pet photography. There are many photographic portraits of dogs by themselves, but we believe photographs that include the dog's master, mistress, or other family members are more personal and offer more viewing interest. We will never know the identity of most persons in the photographs, but we can appreciate their apparent fondness for dogs. Sometimes handwritten notes appear on the reverse of card-mounted photographs. These notes often identify the person and dog by name as well as provide a date of the sitting.

A dog owner often acquires a breed that reflects his own personality, and the dog may acquire its owner's characteristics, habits, and routine. There is often humor to be found in the apparent similarity of appearance shared by a dog and its owner: facial expression, shape of head, hairstyle, or even a man's whiskers can suggest a likeness to the pet. However, we leave opinions of such likenesses to the eye of the beholder.

With early photographic equipment and techniques, exposure times were long and any motion caused blurring. It took a lot of patience on the part of the photographer to manage restless dogs in the studio, and working with children and dogs together required even more resourcefulness. Dogs panted in the warm studio, confused or excited by the unfamiliar surroundings;

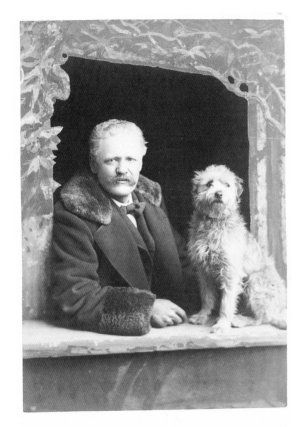

P. O. BLOCK,
MANCHESTER, N. H.

children could be irritable or bewildered. If the photographer were a stranger to the dog, his commands to the dog were probably of little effect. To gain cooperation, photographers would use aids such as noisemakers, toys, and food to help hold the attention of their wiggling subjects. Photographic assistants, if any, and parents lent support off-camera.

One does wonder how much effort was taken to persuade these dogs to remain still long enough for an exposure. In fact, in many of the photographs, the dog is almost a blur from movement. Most photographers offered "satisfaction guaranteed," so why did people accept and pay for such photographs? Maybe the customer felt it was more important to have the humans in focus than the pets. Perhaps the explanation is that many attempts were made, but none were a complete success, so the customer accepted the best image available.

Dogs with family groups, stage personalities, or hunters were a special challenge for photographers. Time for creative composition was limited, but many of the photographs are of high quality—a tribute to the photographer's skill.

Creating suitable studio props was another challenge—and opportunity—for photographers. Painted backdrops, draperies, chairs, grass mats, fences, trees, and many other props were among photographers' resources. Successful use of these props and the amount of experience and skill is certainly reflected in their work.

Many of the dogs sitting on fancy posing chairs appear uneasy. Perhaps it was the first time they were allowed to sit on furniture—or even be indoors. Some dogs used in early photography were the property of the photographer. Traveling photographers generally used their own dogs. A dog pulling a cart full of children was a recurring theme used by the traveling photographer.

Some of the sleeping dogs appear to be the work of a good taxidermist. Although it has been asserted by at least one writer that some of the dogs depicted in studio portraits were indeed stuffed, we have been unable to find any evidence to support this claim.

However, ceramic and metal dog figures were sometimes used as props. The intent was to lend an atmosphere of warmth and realism to the scene. This emulated a popular practice of painters during the Victorian period: they included a dog in family portrait paintings as a symbol of hearth and home.

When no dog, real or artificial, was available, the photographer sometimes incorporated a dog into the photograph through a photomontage—that is, a standard image of a dog would be double exposed onto the portrait. Negatives for such generic images were available from suppliers of photographic stock, and could be ordered along with other props and painted backdrops.

When George Eastman's Kodak camera brought snapshot photography to the masses at the end of the nineteenth century, fewer and fewer families made their way to the photographer's studio for a formal sitting.

Today, the inclusion of dogs in such portrait photography is rather limited. Perhaps this book will encourage the reader to capture that special relationship we share with our canine friends, continuing the rich tradition presented here.

Daguerreotype [1839–1860]

This early photographic process, in which the image was produced on a silver or silver-coated copper plate, was developed in France by Louis J. M. Daguerre and publicly disclosed in 1839. Because this type of plate was thin and fragile, it had to be protected by a mat covered by glass and sealed in a miniature case. Daguerreotypes were popular in the 1840s and 1850s, and the technique was used primarily for portraits.

Because the camera lens had to be open for several seconds to create a daguerreotype, any movement on the part of the subject would lend a "fuzziness" to the final image. Therefore, sharp images of dogs in daguerreotypes are uncommon.

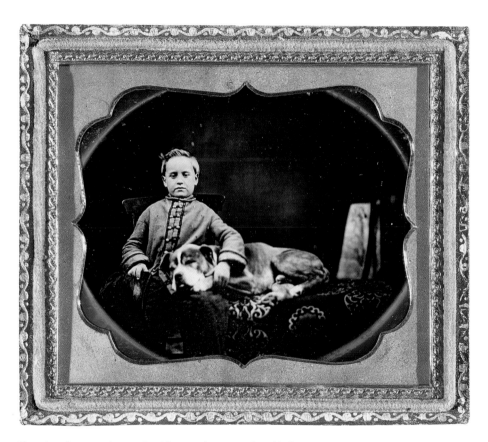

Sleeping dogs made good subjects—they were less likely to wriggle and cause blurring.

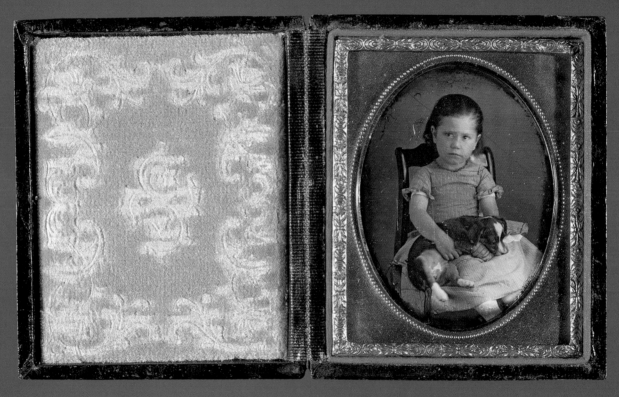

A young girl and her puppy might have spelled disaster for a daguerreotypist; lucky for all that this pup decided to nap.

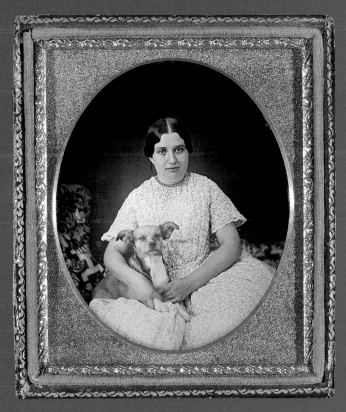

A young lady holding a miniature mixed breed, ca. 1850.

"It took a lot of patience on the part of the photographer to manage restless dogs in the studio… working with children and dogs required even more resourcefulness."

Ambrotype [1852–1865]

The ambrotype was developed in England by Frederick Archer in 1852. In this process, a negative image was produced on a glass plate which had been sensitized with silver nitrate. In order to make the image appear as a positive photograph, the reverse of the glass plate was painted black or backed with black paper, cardboard, or fabric. In addition, ruby-colored glass was sometimes used for the plate.

As with daguerreotypes, ambrotypes had to be glass-covered and placed in cases for protection. Ambrotypes of dogs are not common, and in those that do survive, dark-colored dogs are often poorly defined and blurring from movement appears frequently.

Cases for holding ambrotype images were made in several sizes, depending on the plate dimensions. Slight variations in size occurred, but these general standards were used: full plate (6½ by 8½ inches); one-half plate (4¼ by 5½ inches); one-quarter plate (3¼ by 4¼ inches); one-sixth plate (2¾ by 3¼ inches); one-ninth plate (2 by 2½ inches); and one-sixteenth plate (1⅜ by 1⅝ inches).

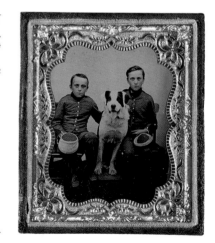

Young cadets with their dog (one-sixth plate), ca. 1855.

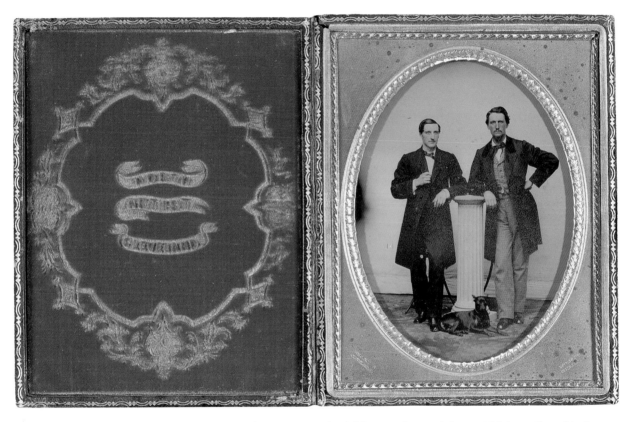

Hand-colored one-half plate in fancy case. Note the posing stands, visible near the men's legs, which keep the subjects steady. Photographer: William North, Cleveland.

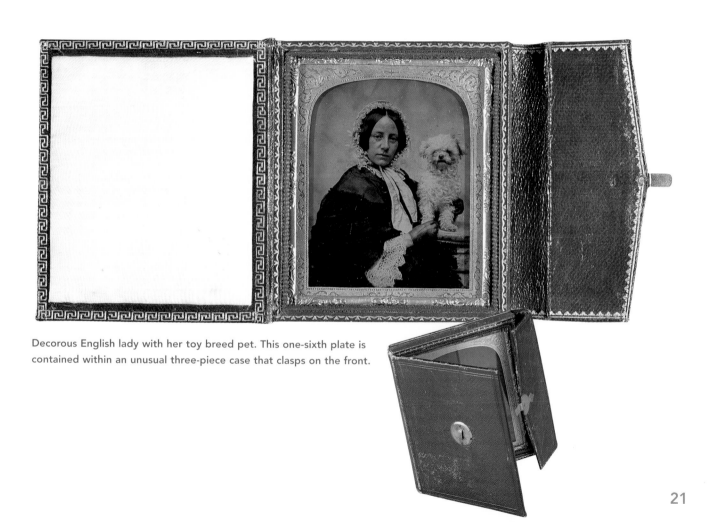

Decorous English lady with her toy breed pet. This one-sixth plate is contained within an unusual three-piece case that clasps on the front.

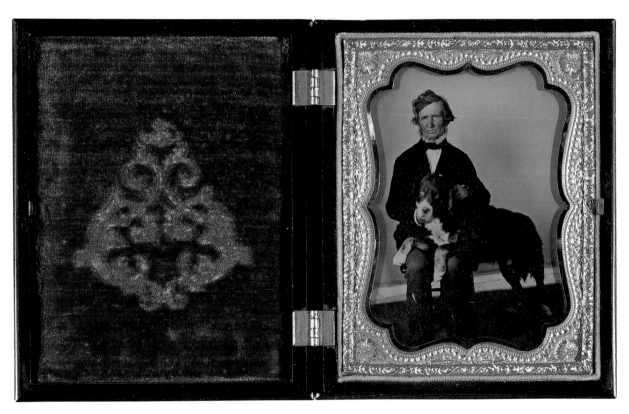

Despite his elegant clothes, this gentleman doesn't seem to mind his dog's lapdog pose (one-fourth plate).

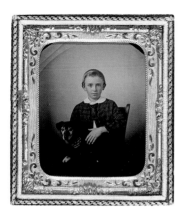

Gentle portrait on one-sixth plate.

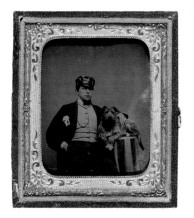

Note the slight blurring of the dog's face (one-sixth plate).

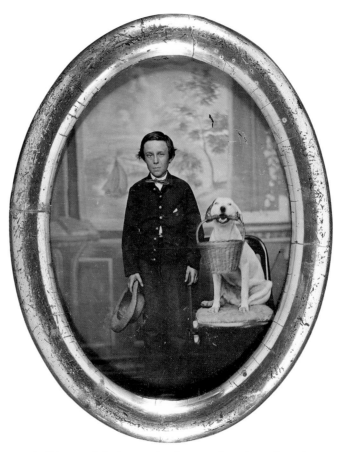

In this rare, full-plate oval ambrotype featuring a formal backdrop, a country boy with straw hat poses as his dog holds a holiday basket, ca. 1860.

Tintype [1856–1930s]

This photographic process was developed in the United States in 1856 by Hannibal Smith: it is also known as the ferrotype, or melainotype, process. The image was produced on a thin, varnish-blackened iron plate; its dark and dull finish often resulted in a lack of sharpness.

Most popular from 1860 to 1900, tintypes were readily available and affordable. The early tintypes were mounted in cases like those for daguerreotypes and ambrotypes. Still made well into the 1930s, tintypes were placed in paper holders, affixed to cards made for the carte-de-visite photographs, or simply left unmounted. Dog images on tintypes are more common than daguerreotypes or ambrotypes but they are not plentiful.

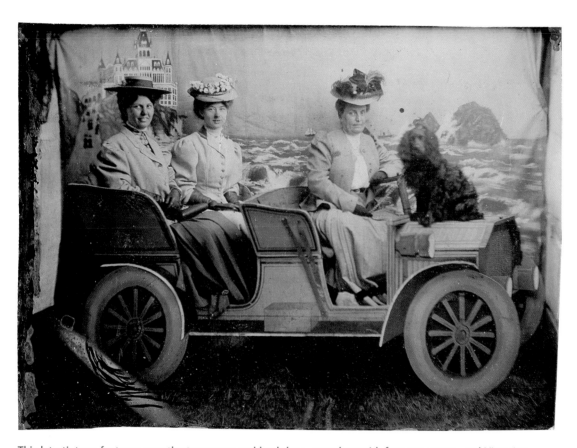

This late tintype features over-the-top props and backdrop, complete with faux car, ocean, and Victorian castle—a souvenir photo of a trip to the seaside.

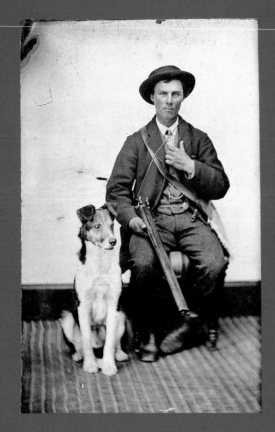

Proud hunter with all of his gear; his dog
appears alert to off-camera action.

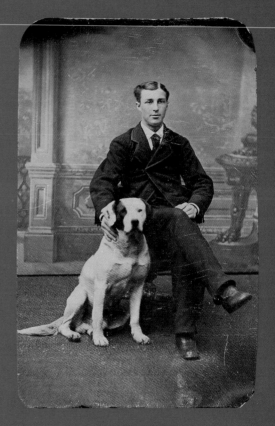

Retriever mix and owner pose against a grand
painted faux interior studio backdrop.

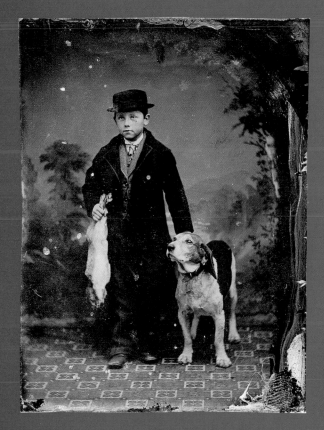

Uncased image of boy with obedient dog, ca. 1870.
The rabbit was probably a studio prop.

"Time for creative composition was limited, but many of the photographs are of high quality—a tribute to the photographer's skill."

27

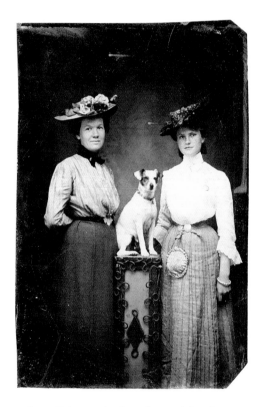

A beautiful portrait of mother and daughter
with their terrier mix on a pedestal.

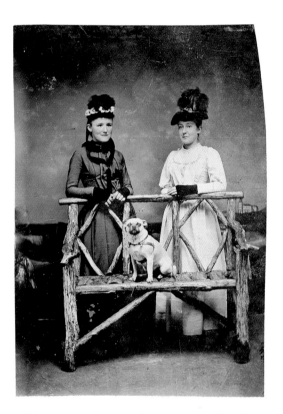

This pug-type dog, perched on a casual bench,
takes center stage.

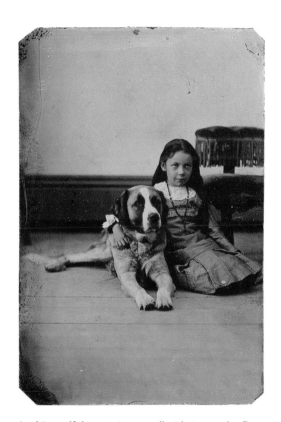

In this soulful portrait, a small girl sits on the floor to be in the same frame as her large dog.

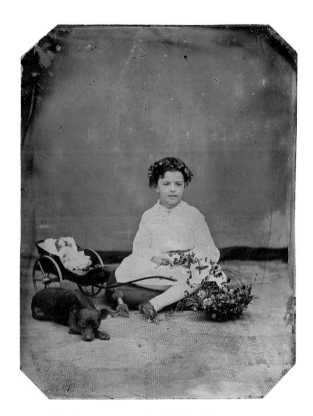

In another floor portrait, the child and dog are posed with toys and hand-tinted flowers.

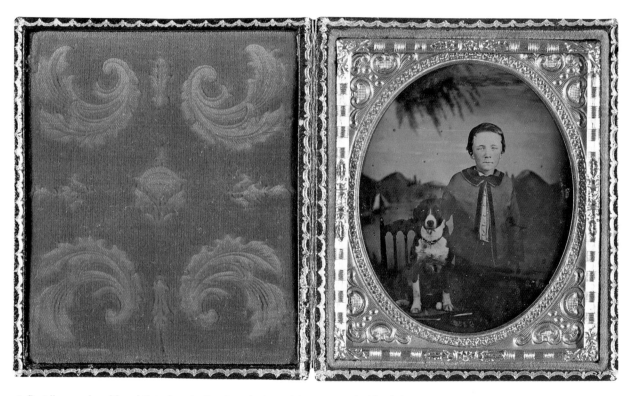

A floridly cased and hand-tinted portrait set against an elaborate tropical backdrop.

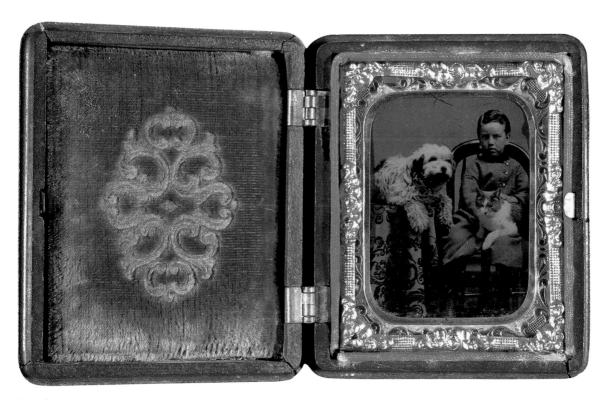

Cased tintype with rare depiction of a dog and a cat together. The photographer did an impressive job of keeping the trio still (one-ninth plate), ca. 1860.

31

Carte-de-visite

[1854–1905]

Introduced in France by André Disdéri in 1854, *carte-de-visite* means "visiting card." It is a paper photograph usually measuring 2¼ by 3½ inches mounted on a 2½ by 4–inch card, although slight variations in size occur.

Created with multilens cameras and glass-plate negatives, the carte-de-visite (or CDV) could be produced in multiples for very little cost. This added greatly to its popularity during the 1860s and 1870s, when small albums were made specifically to hold these photographs.

Carte-de-visite dog images are not common, but they are more prevalent than in earlier formats. Of course, this is primarily

because CDVs—produced cheaply over a longer period of time than other formats—were themselves more prevalent.

A greater variety of studio props began to appear with the carte-de-visite's rise in popularity. Posing chairs and tables were used more often for dog portraits. For some unexplained reason, dogs pictured with men were more common than dogs shown with women or children.

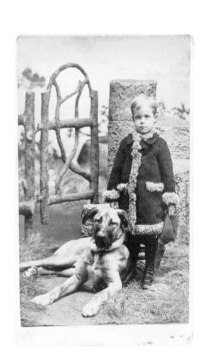

A little boy in his winter coat poses with a large dog in front of an elaborate studio gate scene with faux grass-lined path. Photographer: T. J. & A. R. & Old Photographers, Balston Spa, New York.

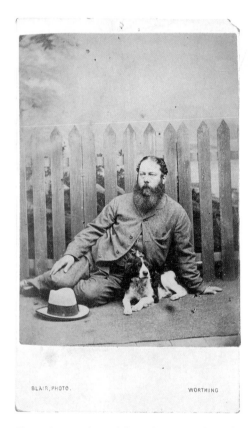

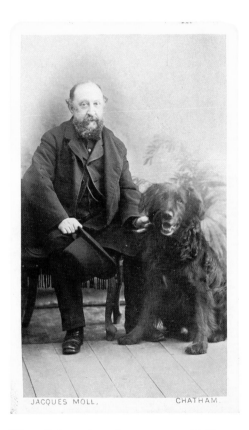

Unusual pose of an adult on the "ground," with his springer spaniel–type dog. Photographer: Blair Studio, Worthing, England, ca. 1870.

This well-dressed gentleman poses with his very large working dog mix. Photographer: Jacques Moll, Chatham, England.

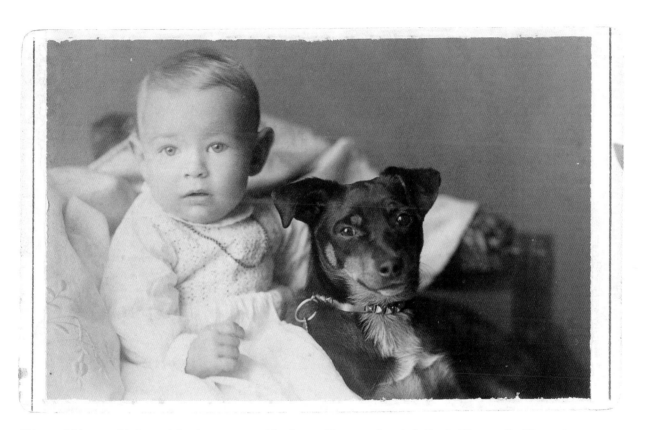

This candid image of babe and dog is very unusual for its era. Photographer: J. A. Brush, Minneapolis, Minnesota.

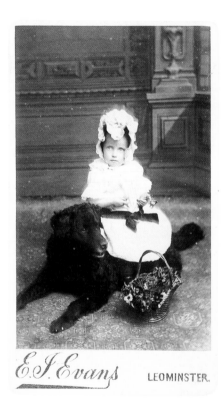

E. J. Evans LEOMINSTER.

A well-dressed little girl actually takes her pose on top of her patient dog. Photographer: E. F. Evans, Leominster, England.

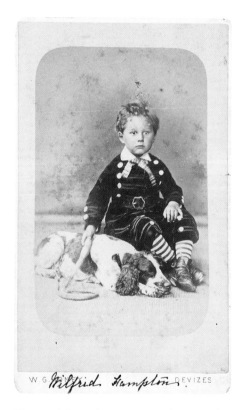

W. G. *Wilfrid Hampton* DEVIZES

The spaniel-mix dog appears unthreatened by the prop whip held by his master. Photographer: W. G. Honey, Devizes, England.

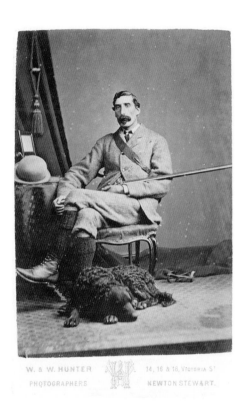

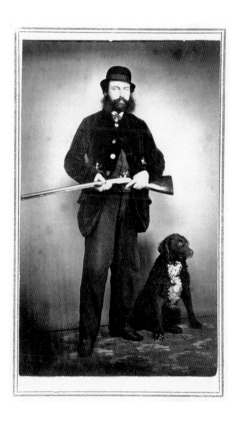

W. & W. HUNTER
PHOTOGRAPHERS

14, 16 & 18, Victoria St.
NEWTON STEWART.

Hunters of the period appeared to be
equally proud of their rifles and their dogs.
Scenes such as these were extremely popular
subjects for the carte-de-visite photographer.

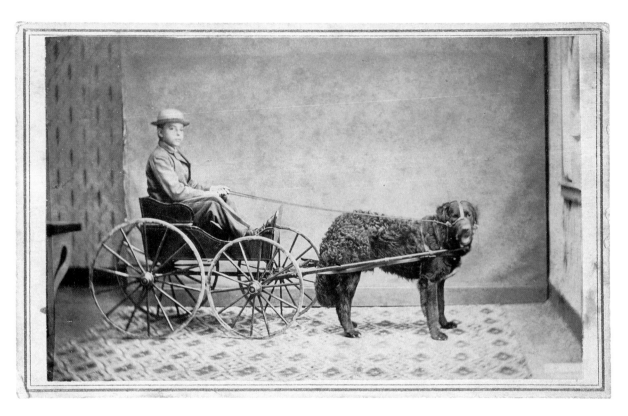

In this elaborate composition, the dog serves as pony. Photographer: Mr. & Mrs. Cornell, Waterloo, New York.

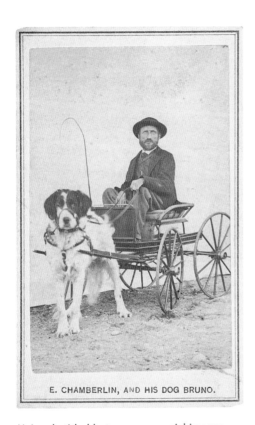

E. CHAMBERLIN, AND HIS DOG BRUNO.

Uniquely titled but noncommercial image:
"E. Chamberlin, and his dog Bruno."

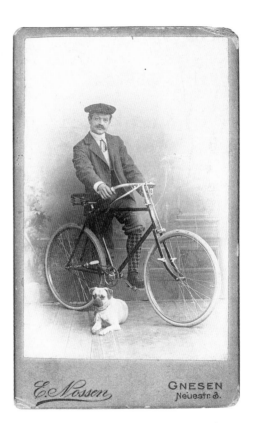

E. Nossen

GNESEN
Neuestr. 3.

Common pug type poses with sporty cyclist.
Photographer: E. Nossen.

39

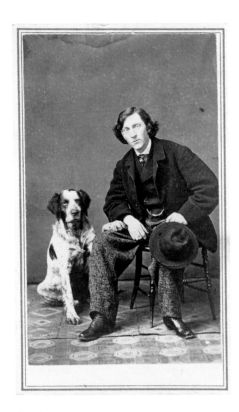

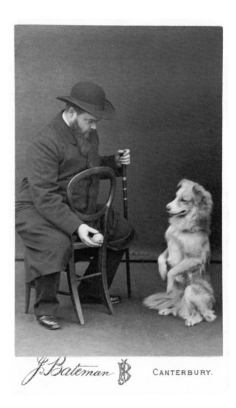

The dog's paw resting on its master's leg and the man's forward pose creates a sweet emotional tension. Photographer: Dunn's Photographic Gallery, Meadville, Pennsylvania.

In a successful action shot, a man offering a ball to his eager dog creates a distinctive composition. Photographer: J. Bateman, Canterbury, England.

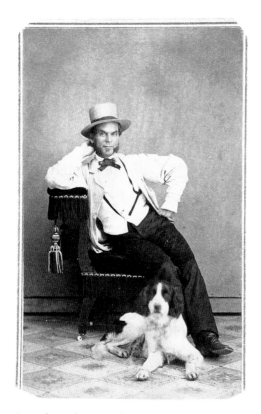

A top-hatted man strikes a dramatic pose, as a springer spaniel mix lounges at his feet.

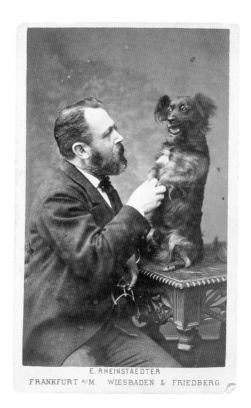

E. RHEINSTAEDTER
FRANKFURT A/M. WIESBADEN & FRIEDBERG.

Perhaps a typical active pose for this dog: master keeps both leash and dog in hand, Germany, 1889.

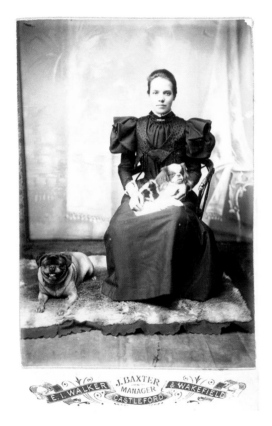

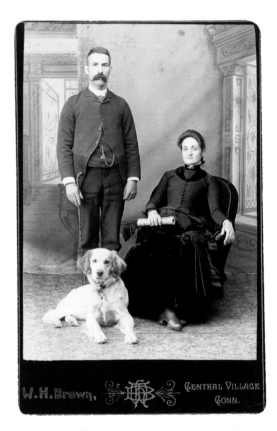

Pug type (left) and King Charles spaniel type (right) with obviously palace-inspired studio props.

Faux painted backdrops attempt to create the illusion of a grand home.

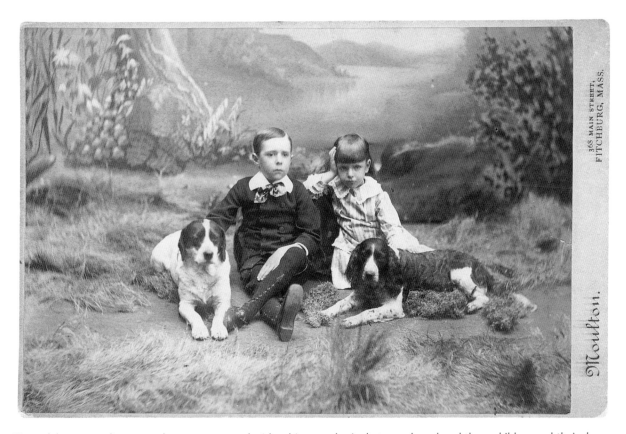

More elaborate studio sets and props were used with cabinet cards. A photographer placed these children and their dogs in a pastoral setting with faux grass.

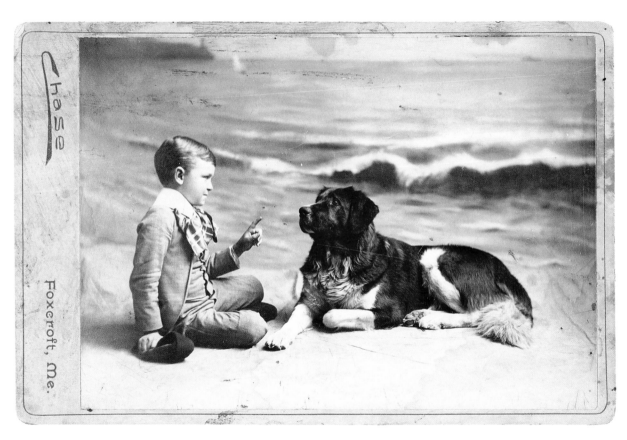

This charming scene of a boy and his dog features a faux seaside setting; perhaps a souvenir of a visit to Maine.

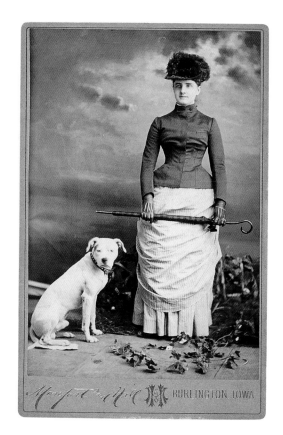

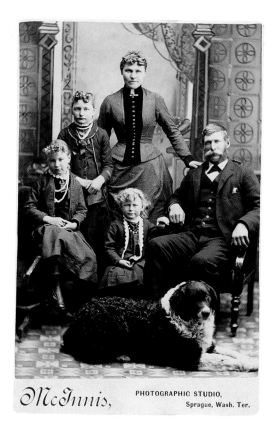

A fashionable young woman and her bull terrier–type dog appear to be taking an autumn stroll.

Be they large or small, family portraits are often not complete without the family dog.

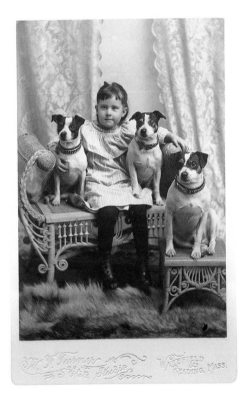

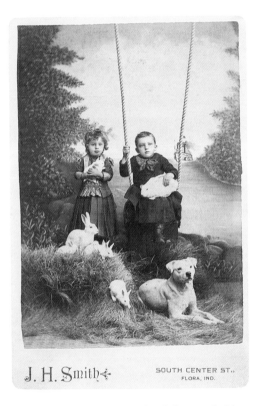

One can only wonder what attention-getting ploy has all four pairs of eyes so riveted off-camera.

It is a well-behaved dog indeed that can hold a pose amid such distraction. Luckily for all, the live rabbits are photographer's props.

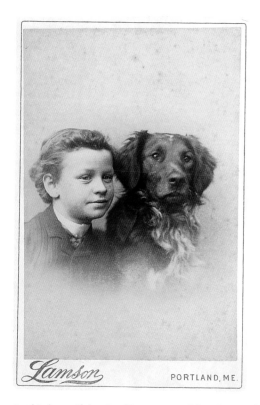

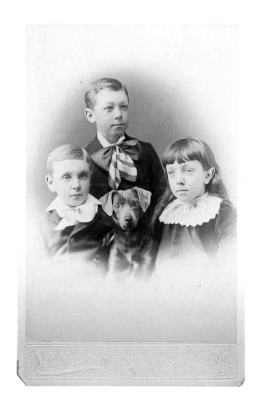

In this beautiful pair of images, traditional portrait
shadowing techniques are employed successfully
with dogs as well as people.

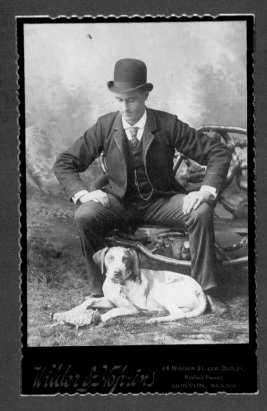

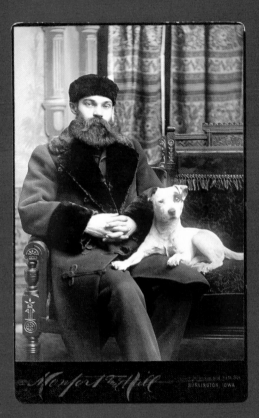

It is clear that the dog is the center of everyone's attention in this appealing pose.

Portraits of immigrants often displayed clothing and furnishings from their homelands.

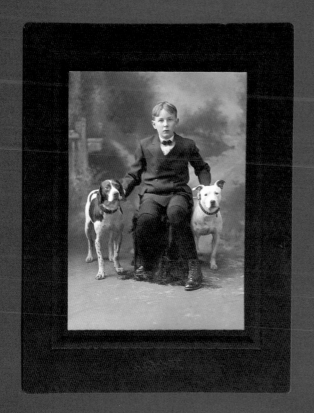

A perfect portrait of a boy flanked by his bull terrier- and pointer-type dogs. Photographer: J. E. Hayt, Erie, Pennsylvania, ca. 1915.

"Even though exact breed identification is difficult, it is still fascinating to attempt to recognize dog types... some of which are clearly progenitors of today's purebreds."

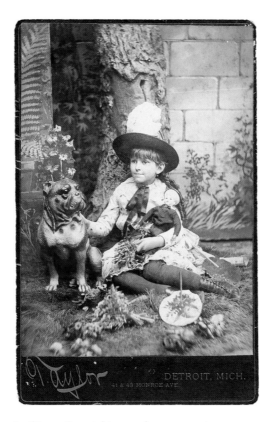

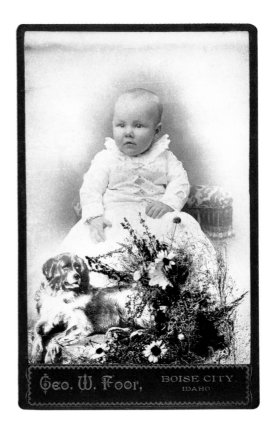

As this sentimental image shows, ceramic prop dogs could always be substituted if a real dog was not available.

Photomontage of baby with two other idealized stock photographs superimposed. The dog image serves as a romantic Victorian symbol of "family."

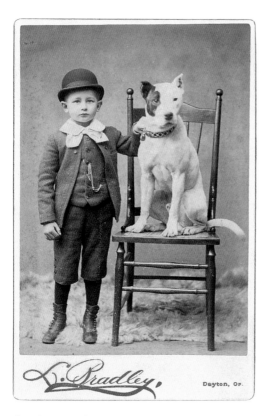

L. Bradley.

Dayton, Or.

The photographer's chair brings this bull terrior–type dog to a height almost equal that of his young master.

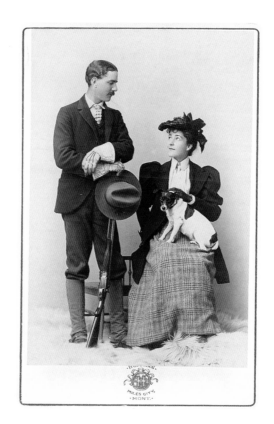

MILES CITY, MONT.

A smooth-haired fox terrier type is as dapper as its well-dressed owners. Photographer: L. A. Huffman, Miles City, Montana, ca. late 1890s.

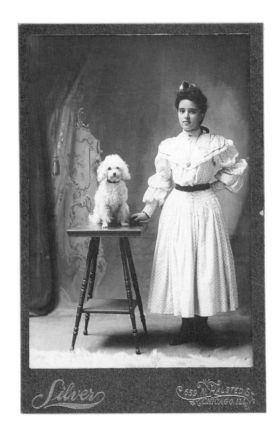

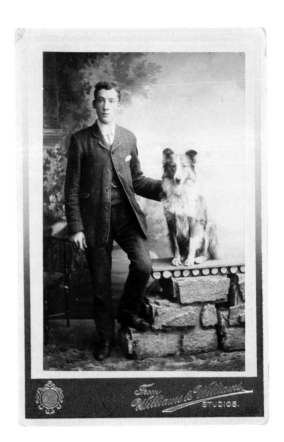

Purebred dogs like this poodle begin to be seen in cabinet cards.

A collie type sits at attention with his owner's arm around him.

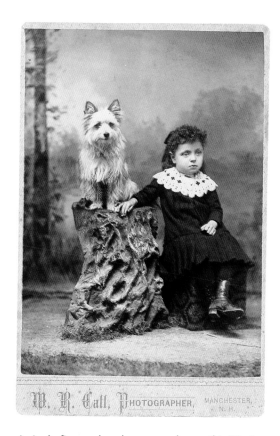

W. R. Call, PHOTOGRAPHER, MANCHESTER, N. H.

A single finger placed over paw keeps this West Highland terrier type perched on its rock.

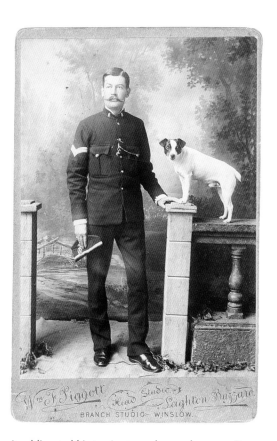

Wm. F. Piggott, Head Studio, Leighton Buzzard. BRANCH STUDIO - WINSLOW.

A soldier and his terrier-type dog each snap suitably to attention.

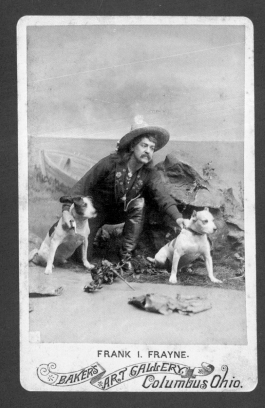

FRANK I. FRAYNE.

BAKER'S ART GALLERY, Columbus Ohio.

Theatrical performers often posed with dogs for promotional photographs.

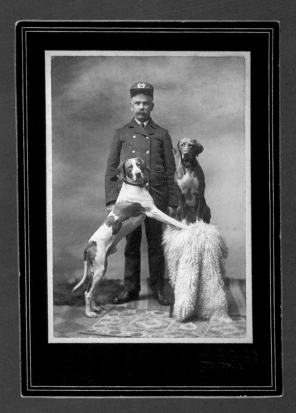

A fireman with his well-posed pointers. Photographer: Henry Wedekin, ca. 1910.

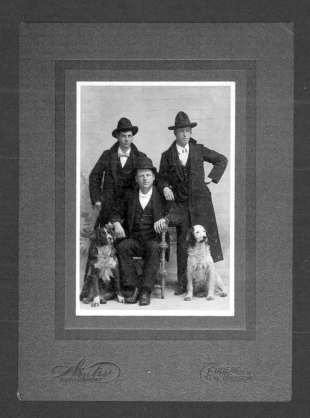

Warmly dressed gentlemen pose in studio comfort with their spaniel mix dogs, Eugene, Oregon, ca. 1900.

"Although it has been asserted…that some of the dogs depicted in studio portraits were indeed stuffed, we have been unable to find any evidence to support this claim."

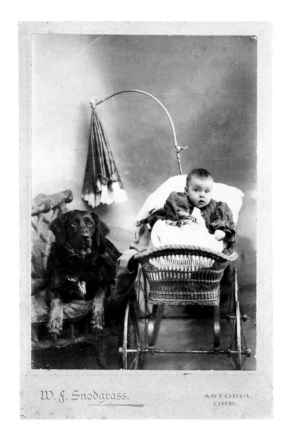

W. F. Snodgrass. ASTORIA, ORE.

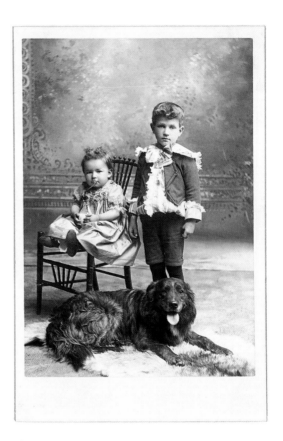

Babies with dogs held universal appeal in Victorian society.

These young charges appear to be well protected by their faithful friend.

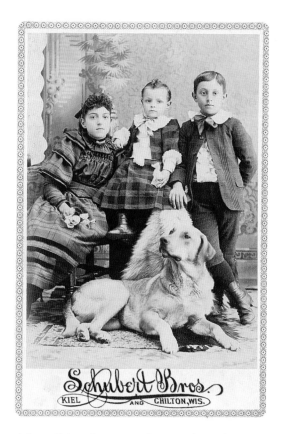

Schubert Bros.
KIEL AND CHILTON, WIS.

A beautiful retriever-type dog completes this charming group portrait.

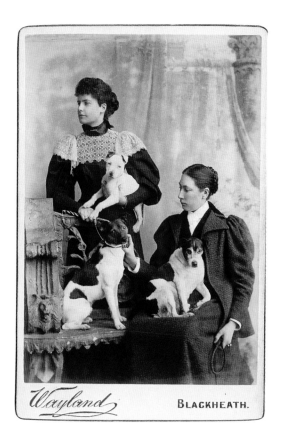

Wayland

BLACKHEATH.

A firm collar hold was obviously needed to keep this trio so well behaved.

59

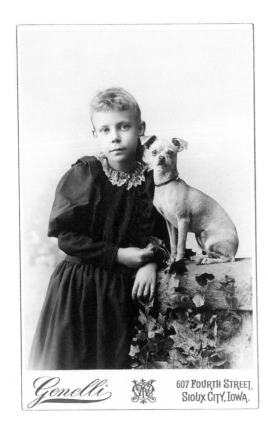

Genelli 607 FOURTH STREET,
 SIOUX CITY, IOWA.

This faux vine-covered wall creates a lovely composition of a young girl and her very proud dog.

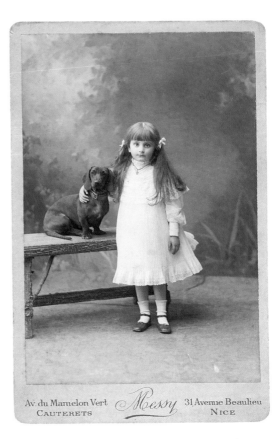

Av. du Mamelon Vert Messy 31 Avenue Beaulieu
CAUTERETS NICE

Even the aid of a bench doesn't quite bring this dachshund to equal height with its mistress.

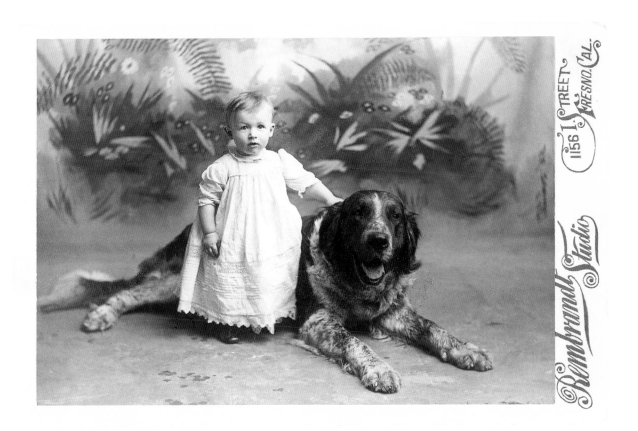

Here again the photographer managed a brilliantly balanced composition with subjects small and large.

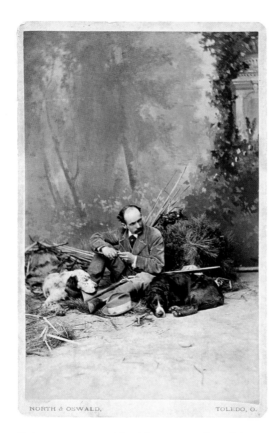

NORTH & OSWALD, TOLEDO, O.

Elaborate props and backdrops evocative of the chase were often used for hunting scenes.

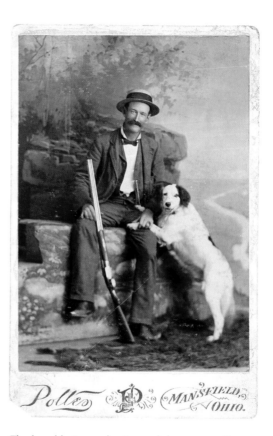

Polles MANSFIELD, OHIO.

The bond between hunter and dog was sentimentally displayed.

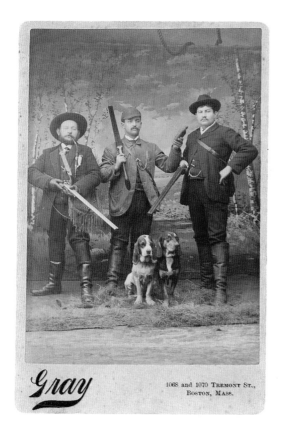

Hunting groups were posed with great serious-
ness; especially here with the pair of hounds.

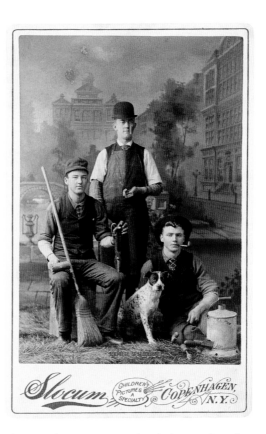

These tradesmen are posed with their tools and
the shop dog; note the caption "four tramps."

63

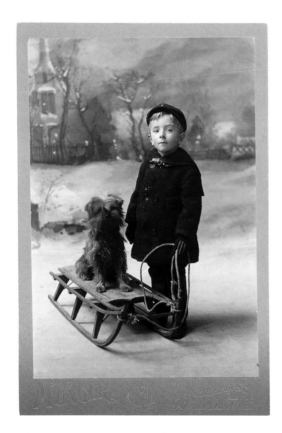

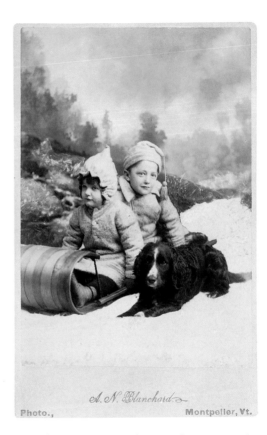

This young man and his best friend pose in front of an elaborately painted winter scene.

Using faux snow or ice, photographers recreated winter scenes indoors without chilling the subjects.

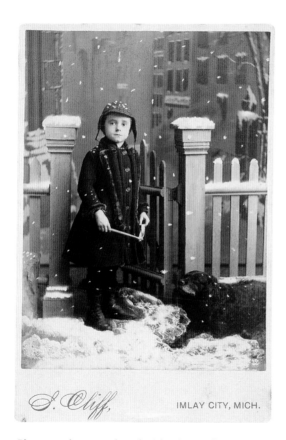

Photographers employed tricks during the printing process to simulate falling snow.

Photographers often mounted their cabinet cards on ornately backed board, like the one shown here.

Stereograph [1845–1930s]

The stereograph or stereoview is a 3½ by 7–inch card mounted with two photographs side by side. Each of these photographs differ only slightly in perspective. When viewed through a stereo-scope—an optical instrument with two eyeglasses for helping the viewer to combine two images—the effect is three-dimensional. Englishman Charles Wheatstone invented the stere-oscope in 1845. Stereoscopic daguerreotypes (on silver-coated copper plates) appeared before the standard paper models.

Almost every type of subject matter was captured on stere-oviews, which reflected the varied interests of the public. Images were produced for commercial resale—boxed sets of stereocards were popular in both private homes and public libraries.

Personal portraits in this format are not common, nor are dog portraits, except as commercial images that feature sentimental or humorous poses.

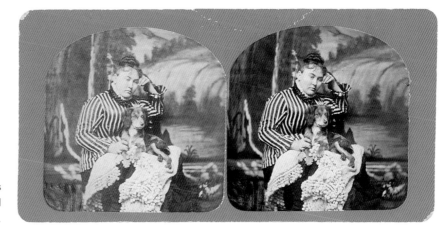

In this rare personal portait, a woman poses with her lap dog sitting on a crocheted blanket against an elaborate backdrop.

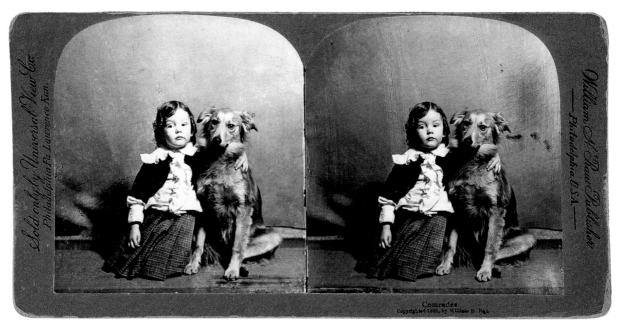

Sentimental images were produced for commercial sale. This stereoview of a little boy with dog is entitled "Comrades," 1895.

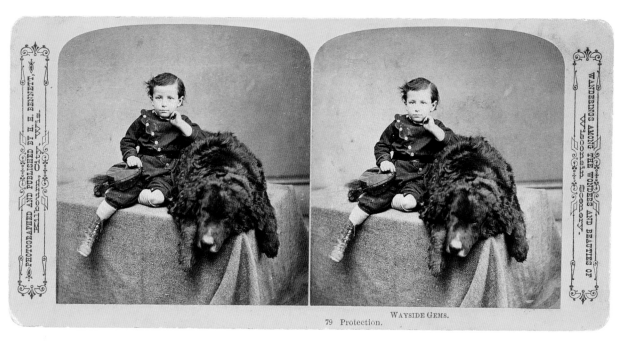

WAYSIDE GEMS.

79 Protection.

"Protection," a commercial image from the series "Wanderings among the Wonders and Beauties of Wisconsin Scenery."

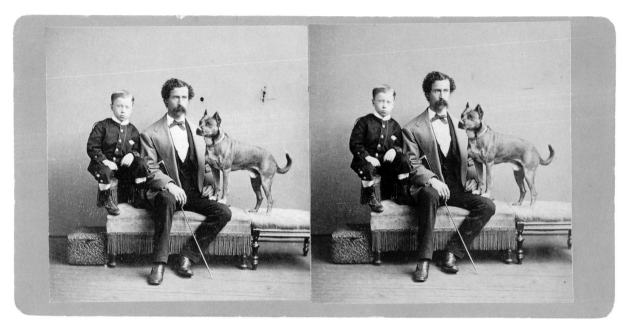

Personal portrait of a father and son with their pit bull–type dog.

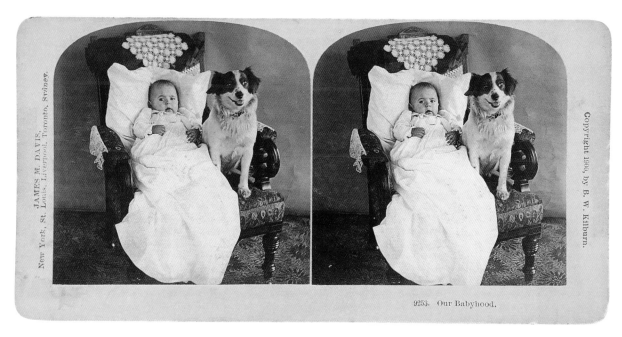

Commercial image of infant and dog entitled "Our Babyhood," 1900.

Photo Postcard
[1866–1920s]

In 1866, when the postal service began allowing cards to be sent by mail, photographers seized the opportunity to provide photographic postcards to their customers. Photographic supply manufacturers provided sensitized paper preprinted with the postcard label and a place for the stamp. The standard size for these postcards was 3 ½ by 5 ½ inches.

Photographic postcards taken in studios were most popular before 1920 and there are many fine examples of dog portraits with people in this format.

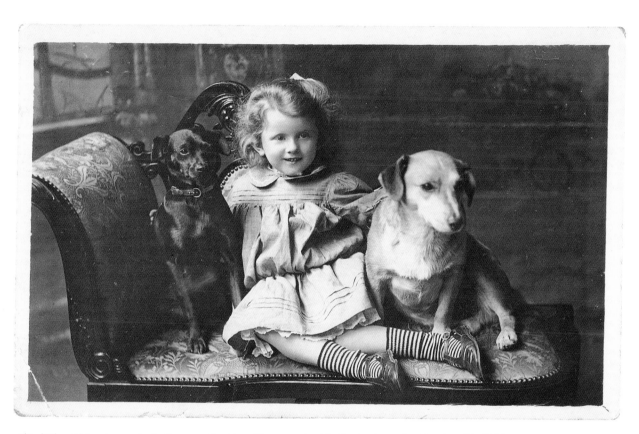

This little girl has two pals, both very attentive. Photographed in Perth, Australia, October 12, 1908.

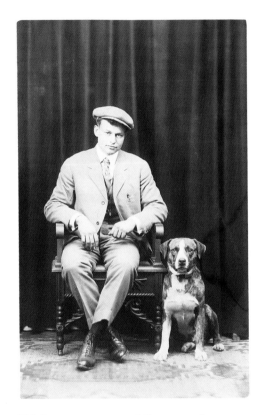

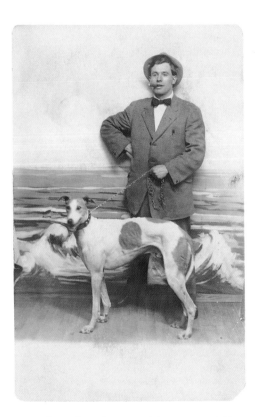

This jaunty young man strikes a casual pose, while his dog remains alert, ca. 1915.

A greyhound strolls a "seaside promenade" with his cigar-smoking master, ca. 1915.

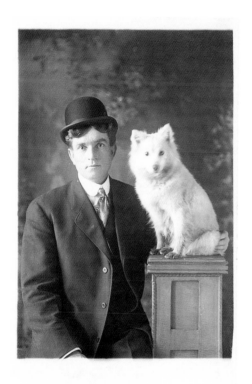

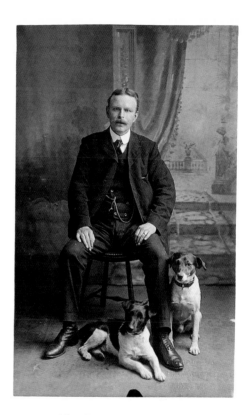

A man with his spitz-type dog posing on a podium, ca. 1915.

A man and his dogs. Photographer: Sidney Smith, Pickering, Ontario, Canada.

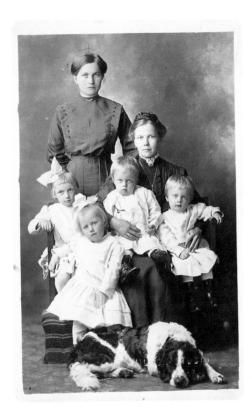

Family photo. Photographer: Wilson Studio, Astoria, Oregon, ca. 1910.

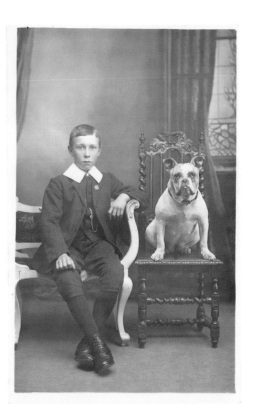

A big bulldog seated on his own elegant chair beside his master, ca. 1910.

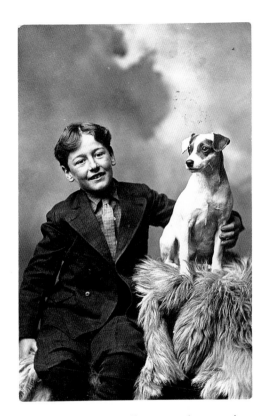

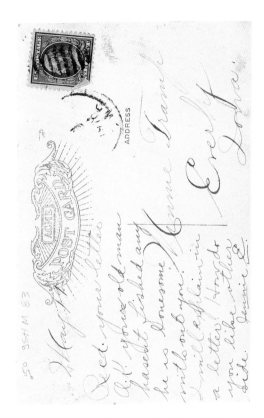

The flip side of this well-composed postcard portrait says: "Received your letter O.K. Your old man hasn't fished any.

He is lonesome without you. I will explain in a letter. How do you like the other side. Jennie Everly." May 19, 1908.

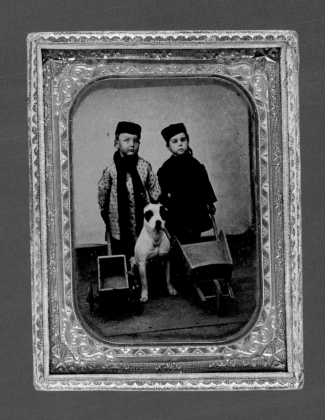

further reading

Anthony's Photographic Bulletin, New York, June 1871.

Briggs, Asa. *Victorian Portrait*. New York: Harper & Row Publishers, 1989.

The Complete Dog Book: Official Publication of the AKC. New York: Howell Book House, 1992.

Cox, Paul. *Beautiful Ambrotypes*. London: Travelling Light Publishers, 1989.

Crawford, William. *The Keepers of Light*. Dobbs Ferry, N.Y.: Morgan & Morgan, Inc., 1979.

Darrah, William C. *Cartes de Visite in Nineteenth Century Photography*. Gettysburg, Pa.: W. C. Darrah Publisher, 1981.

Haller, Margaret. *Collecting Old Photographs*. New York: ARCO Publishing Co., Inc. 1978.

Harker, Margaret. *Victorian and Edwardian Photographs*. London: Charles Letts Books Limited, 1982.

Henisch, Heinz K. and Bridget A. *The Photographic Experience, 1839–1914*. University Park: Pennsylvania State University Press, 1994.

Linkman, Audrey. *The Victorians: Photographic Portraits*. London: Tauris Parke Books, 1993.

Mace, O. Henry. *Collectors Guide to Early Photographs*. Radnor, Pa.: Wallace-Homestead Book Company, 1990.

McCulloch, Lou W. *Card Photographs*. Exton, Pa.: Schiffer Publishing Ltd., 1981.

Morgan, Hal, and Andreas Brown. *Prairie Fires and Paper Moons: The American Photographic Postcard 1900-1920*. Boston: David R. Godine Publisher, 1981.

Newhall, Beaumont. *The Daguerreotype in America*. New York: Dover Publications Inc., 1976.

Noble, Alexandra, ed. *The Animal in Photography, 1843–1985*. London: Photographers Gallery, 1986.

Rodgers, H. J. *Twenty-three Years under a Sky-light, or Life and Experiences of a Photographer*. Hartford, Conn., 1872.

Seiberling, Grace. *Amateurs, Photography, and the Mid-Victorian Imagination*. Chicago: University of Chicago Press, 1986.

Welling, William. *Collector's Guide to Nineteenth Century Photographs*. New York: Collier Books, 1976.

Wick, Rainer, ed. *Dogs in Focus*. Germany: Kunstverlag Weingarten GmbH, Weingarten, 1989.

Wood, John. *The Daguerreotype*. Iowa City: University of Iowa Press, 1989

Wilcox and Walkowicz. *Atlas of Dog Breeds of the World*. Neptune City, N.J.: TFH Publishers, 1989.

MEREDITH, N. H.

Edited by Marisa Bulzone
Designed by Alexandra Maldonado
Graphic Production by Maryann De George

The text of this book was composed in
Bauer Bodoni, captions were
composed in Avenir Book.
Printed and bound in Singapore
by Tien Wah Press